Magic and Mystical Symbols

Symbols

CD-ROM and BOOK

DOVER PUBLICATIONS, INC.
Mineola, New York

The CD-ROM in this book contains all of the images. There is no installation necessary. Just insert the CD into your computer and call the images into your favorite software (refer to the documentation with your software for further instructions). Each image has been scanned at 600 dpi and saved in six different formats—BMP, EPS, GIF, JPEG, PICT, and TIFF. The JPEG and GIF files—the most popular graphics file types used on the Web—are Internet-ready.

The "Images" folder on the CD contains a number of different folders. All of the TIFF images have been placed in one folder, as have all of the PICT, all of the EPS, etc. The images in each of these folders are identical except for file format. Every image has a unique file name in the following format: xxx.xxx. The first 3 or 4 characters of the file name, before the period, correspond to the number printed with the image in the book. The last 3 characters of the file name, after the period, refer to the file format. So, 001.TIF would be the first file in the TIFF folder.

Also included on the CD-ROM is Dover Design Manager, a simple graphics editing program for Windows that will allow you to view, print, crop, and rotate the images.

For technical support, contact:
Telephone: 1 (617) 249-0245
Fax: 1 (617) 249-0245
Email: dover@artimaging.com
Internet: **http://www.dovertechsupport.com**
The fastest way to receive technical support is via email or the Internet.

Bibliographical Note

Magic and Mystical Symbols CD-ROM and Book, first published in 2004, contains all of the images in the "Magic and Mystic" chapter of *Symbols, Signs & Signets* by Ernst Lehner, first published by World Publishing Company, Cleveland and New York, in 1950 and republished by Dover Publications in 1969.

Dover Electronic Clip Art®

International Standard Book Number: 0-486-99613-1

Manufactured in the United States of America
Dover Publications, Inc., 31 East 2nd Street, Mineola, N.Y. 11501

MAGIC & MYSTIC

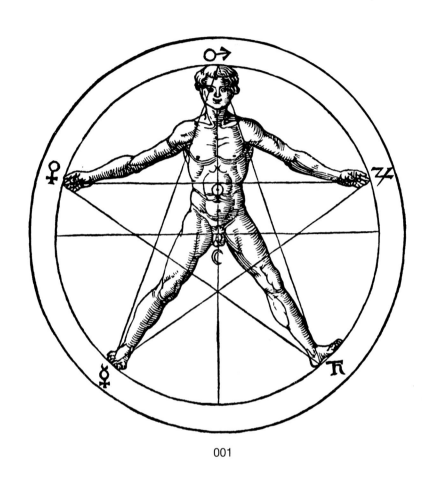

001

LIST OF ILLUSTRATIONS

PAGE 3
001 SYMBOLIC REPRESENTATION OF MAN AS MICROCOSMOS–*(Agrippa)*

PAGE 6
002 SYMBOLIC REPRESENTATION OF MAN AS UNIVERSE *(Chinese)*

PAGE 7
003 UTCHAT–The Sacred Eye *(Egyptian)*
004 SCARAB–Good Luck *(Assyrian)*
005 SYMBOLIC TREE–Life and Knowledge *(Babylonian)*
006 PINE CONE–Life and Fertility *(Semitic)*

PAGE 8
Egyptian Symbols
007 SUN DIAL
008 ANKH–Life
009 LOTUS FLOWER–The Earth
010 SMA–Union
011 THE BUCKLE OF ISIS–Protection
012 SCARABAEUS–Fertility
013 TET OF OSIRIS–Stability
014 VULTURES–The Funeral Birds

PAGE 9
Babylonian–Assyrian Symbols
015–019 CYLINDER SEALS *(Babylonian–Assyrian)*
020 DEVILS TRAP *(Assyrian–Semitic)*

PAGES 10 and 11
Mythological Symbols
021 THE BULL MNEUAS, THE DOVE AND THE SUN DIAL–Providence *(Egyptian)*
022 THE MOON GOD–Providence *(Mesopotamian)*
023 THE SACRED SHIELD OF MARS *(Roman)*
024 THE EGG AND THE SERPENT–Providence *(Greek)*
025 THE OWL OF WISDOM *(Greek)*
026 CADUCEUS–The Lifegiving Wand *(Roman)*
027 THE LAUREL OF VICTORY *(Greek)*
028 ZEUS AND THE GIANTS *(Roman)*
029 PYTHON–The Serpent of the Deluge *(Greek)*
030 MEDUSA–The Terror *(Greek)*
031 TRISKELION–Victory and Progress *(Greek)*
032 COMEDY *(Greek)*
033 CORNUCOPIA–The Horn of Plenty *(Roman)*
034 TRAGEDY *(Greek)*

PAGES 12 and 13
GNOSTIC GEMS from Charles W. King's "The Gnostics and Their Remains"
035–037 ABRAXAS

038 THE MITHRAIC BULL
039 PHOEBUS IN HIS QUADRIGA
040 APOLLO
041 THE DELPHIC E
042 SERAPHIS–The Solar God
043 THE ANGEL OF DEATH
044 FATE

PAGES 14 and 15
GNOSTIC GEMS from Jacob Bryant's "Analysis of Antient Mythology"
045 AURELIA THE BUTTERFLY–Resurrection *(Egyptian)*
046 SEMIRAMIS AND THE DOVES–Providence *(Babylonian)*
047 THE SKY SERPENT–Providence *(Egyptian)*
048 THE SEA BIRD AND THE ARK–Resurrection *(Egyptian)*
049 JANUS–The Beginning and the End *(Roman)*
050 SCARABAEUS CHARM AGAINST ANNIHILATION *(Egyptian)*
051 HELIOS ON THE LOTUS FLOWER–Preservation *(Egyptian)*
052 DOVE AND OLIVE BRANCH–The Rescue *(Greek)*
053 DOVE AND LAUREL BRANCH–Peace *(Greek)*
054 DOVE AND CORNUCOPIA–Good Fortune *(Roman)*
055 LUNA REGIA–The Moon Goddess–Preservation *(Roman)*
056 LEO AND SCORPIO
057 SCORPIO
058 AMOR, THE BEE AND THE DOVE–Love, Prosperity and Peace *(Greek)*

PAGES 16 to 20
Chinese Symbols
059 PAH-KWA AND THE GREAT MONADE–Charm against Evil Forces

Pa-Pao The Eight Precious Things
060 THE DRAGON PEARL
061 THE GOLDEN COIN
062 THE LOZENGE
063 THE MIRROR
064 THE STONE CHIME
065 THE BOOKS
066 THE RHINOCEROS HORNS
067 THE ARTEMISIA LEAF

The Eight Buddhist Symbols of Happy Omen
068 THE CONCH SHELL
069 THE JAR

070 THE UMBRELLA
071 THE CANOPY
072 THE LOTUS FLOWER
073 THE WHEEL OF FIRE
074 THE FISHES
075 THE MYSTIC KNOT
076 SHUI (WATER)–Taoist Charm against Fire
077 THE FIVE GREAT BLESSINGS–HAPPINESS, HEALTH, VIRTUE, PEACE AND LONG LIFE

The Eight Emblems of the Taoist Immortals

078 THE FAN
079 THE FLUTE
080 THE CASTANETS
081 THE LOTUS FLOWER
082 THE BAMBOO TUBES
083 THE GOURD
084 THE SWORD
085 THE BASKET OF FLOWERS

Chinese Flower Symbols

086 PEONY–SPRING–Love and Affection
087 LOTUS–SUMMER–Fruitfulness
088 CHRYSANTHEMUM–AUTUMN–Joviality
089 PLUM–WINTER–Long Life
090 NARCISSUS–Good Fortune
091 PEACH–Immortality
092 ORCHID–Beauty
093 BAMBOO–Longevity
094 SHOU–Long Life

The Four Accomplishments

095 THE HARP–Music
096 THE CHESSBOARD–Sport
097 THE BOOKS–Scholarship
098 THE PAINTINGS–Art
099 KWEI SING–God of Literature

PAGES 21 to 23
Oriental Symbols

100 NOSHI–Humility in Gifts *(Japanese)*
101 AMULET FOR PROTECTION *(Japanese)*
102 CRESCENT AND STAR–Divinity and Sovereignty *(Mohammedan)*
103 LONGEVITY *(Chinese)*
104 THE HOLY AX *(Chinese)*
105 GOOD LUCK CHARM *(Mameluk)*
106 TSUCHI–The Mallet of Luck *(Japanese)*
107 THE DICE OF GOOD LUCK *(Japanese)*
108 SWASTIKA–GOOD LUCK *(Persian–Indian)*
109 KARMA–The Wheel of Law *(Buddhist)*
110 CHAKRA-VARTTA–The Wheel of Law *(Hindu)*

111 HORIN-RIMBO–The Wheel of Law *(Japanese)*
112 SHOU–Longevity *(Chinese)*
113 NADE-TAKARA-NUSUBI–Longevity *(Japanese)*
114 HO-TU–Charm against Evil Spirits *(Chinese)*
115 SHRI-YANTRA–Cosmic Diagram *(Hindu–Vedic)*
116 LONGEVITY *(Chinese)*
117–118 CROSSES WITH THE DIVINE FACE–Good Luck Charms *(Ethiopian)*

PAGE 24
Brahmanic Symbols

119 TRIMURTI SYMBOL
120 LINGAM SYMBOL–Propagation
121 LOTUS FLOWER–Trimurti Symbol
122 TRIMURTI SYMBOL

PAGE 25
Nordic Runes

123 WITCHES FOOT *(Celtic)*
124 INDUCES MADNESS *(Nordic)*
125 AGAINST WITCHCRAFT *(Nordic)*
126 HEAVENLY POWER *(Nordic)*
127 PROTECTS AGAINST POISON *(Nordic)*
128 ANGURGAPI–Uncertainty *(Old Icelandic)*
129 GINFAXI–Victory *(Old Icelandic)*
130 GINNIR–Divine, Demonical *(Old Icelandic)*
131 AEGISH JALMUR–Irresistibility *(Old Icelandic)*
132 CROSS OF WOTAN *(Germanic)*
133 SYMBOL OF THE VEHMIC COURTS *(Germanic)*
134 ACHTWAN *(Germanic)*
135 WOLF'S HOOK *(Germanic)*
136 FIRE EYE *(Germanic)*
137 DRAGON'S EYE *(Germanic)*
138 WOLF'S CROSS *(Germanic)*

PAGE 26
139–142 MAGIC CIRCLES AND WAND OF DOCTOR FAUSTUS from J. Scheible's *"Das Kloster"*
143 DOCTOR JOHANNES FAUST AND MEPHISTOPHELES from Christopher Marlowe's *"Tragic Historie of D. Faust"* (1631)

PAGE 27
Magic Circles

144 THE HOLY MAGIC CIRCLE
145 INDIAN–Mohammedan Magic Circle
146–148 SCHEMHAMPHORAS–Magic Circle to Discover Buried Treasures

PAGE 28
149 THE WITCH BY HANS WEIDITZ from Petrarca's *"Von der Artzney Beider Glück"* (1532)
150–156 THE MAGIC SEALS OF THE SEVEN ANGELS OF THE SEVEN DAYS OF THE WEEK

150 MICHAEL–Sunday

151 GABRIEL–Monday

152 SAMAEL–Tuesday

153 RAPHAEL–Wednesday

154 SACHIEL–Thursday

155 ANAEL–Friday

156 CASSIEL–Saturday

160 LUCIFER

161 BEELZEBUB

162 SATAN

163 ASTOROTH

164 LEVIATHAN

165 ELIMI

166 BAALBARITH

PAGE 29
The Magic Seals of the Three Princes of the World of Spirits

157 PRINCE ALMISHAK

158 PRINCE ASHIRIKAS

159 PRINCE AMABOSAR

160–166 THE SIGNATURES OF THE SEVEN DEMONS from a pact drawn up in 1616 between Lucifer and Urbain Grandier, minister of St. Peter in Loudon, France (Bibliothèque Nationale)

PAGE 30
Magic Amulets

167 MAKES GARMENTS AUSPICIOUS

168 BRINGS SUCCESS, WEALTH, LONG LIFE

169 SECURES THE HELP OF GOOD SPIRITS

170 MAKES BUSINESS SUCCESSFUL

171 MAKES TRAVELING SAFE

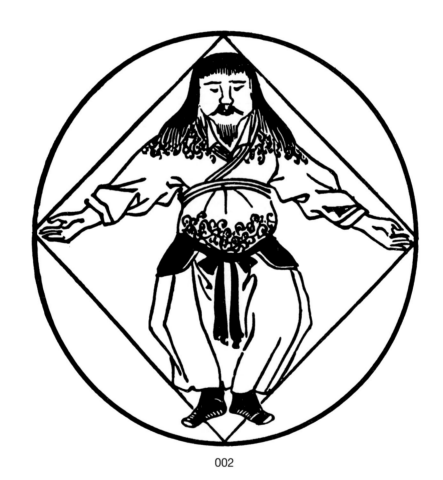

002

003

MAGIC AND MYSTIC

SINCE THE DAWN OF human history man's mind was ruled and dominated by fear and hope of the invisible and impalpable powers behind the phenomena of nature and life, and the inexplicable occurrences around him. He attributed these powers to demons and devils, to angels and good spirits. He invented the weapons of magical and mystical rites and symbols to fight and appease the evil forces and to influence the good ones in his favor.

Rites and symbols of the ancient and oriental polytheistic religions and mythologies, gnostic gems and charms, oracles and mystic signs, Nordic runes, magic circles and amulets all served the same purpose: to exorcise the demons and to entreat the good spirits to give the adept scholar all the desirable things of life and to punish and destroy his enemies.

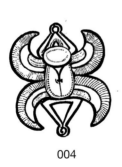

004

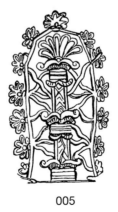

005

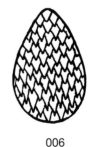

006

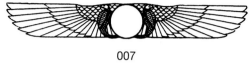

007

008

009

010

011

012

013

014

015

016

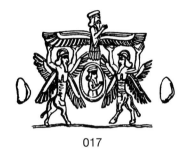

017

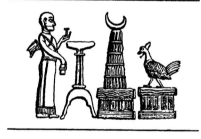

018

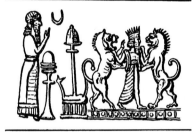

019

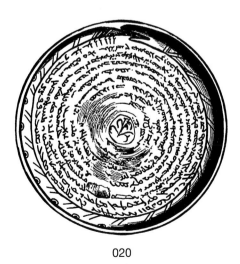

020

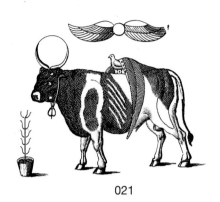

021

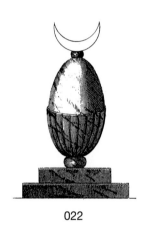

022

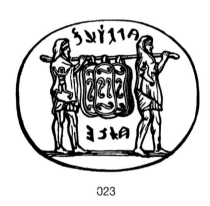

023

024

025

026

027

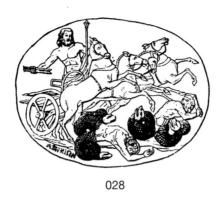

028

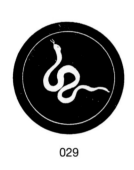

029

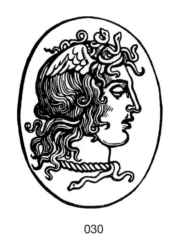

030

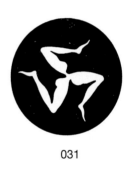

031

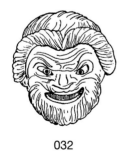

032

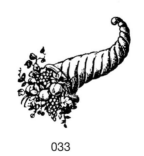

033

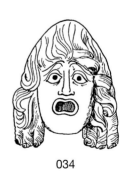

034

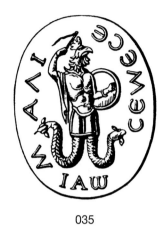

035

036

037

038

039

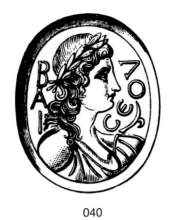

040

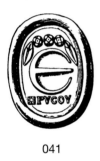

041

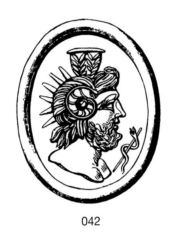

042

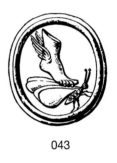

043

044

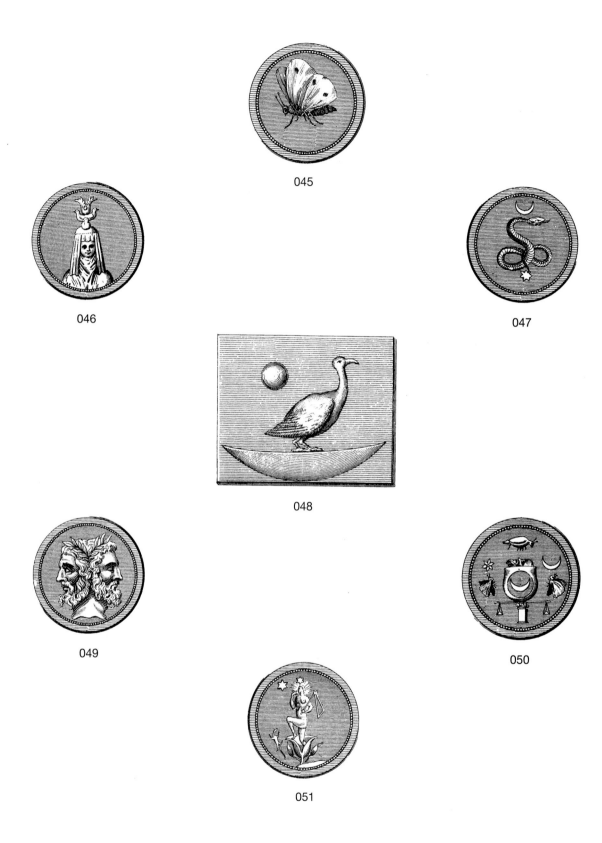

045

046

047

048

049

050

051

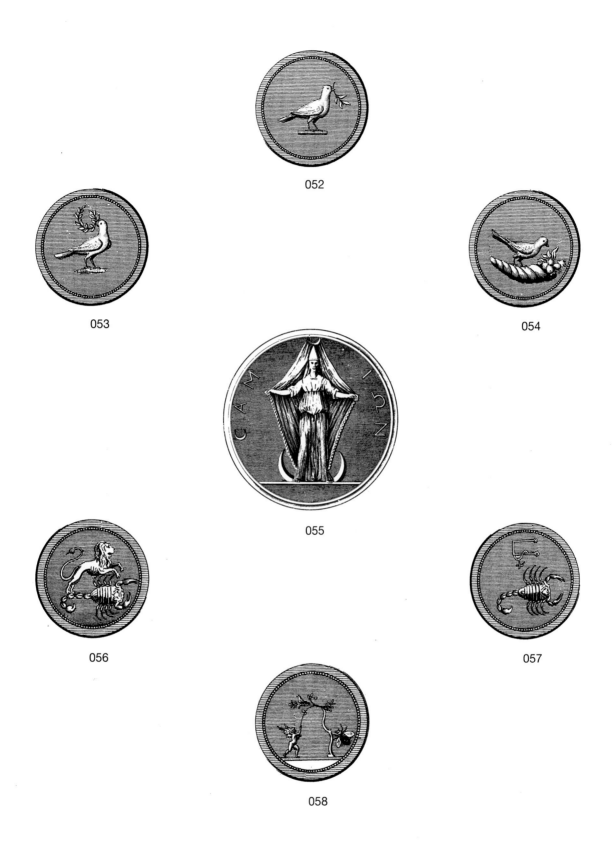

052

053

054

055

056

057

058

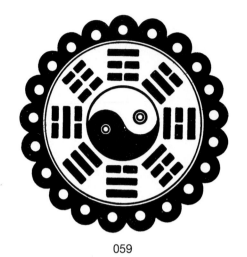

059

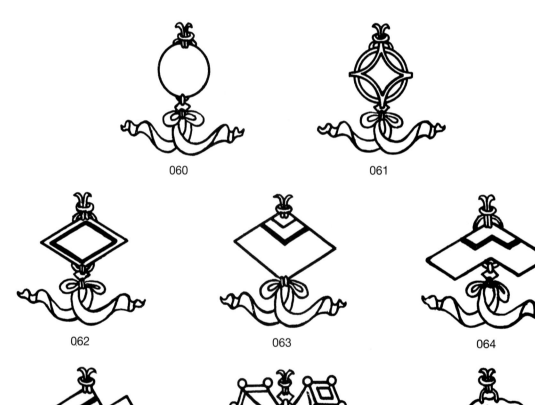

060

061

062

063

064

065

066

067

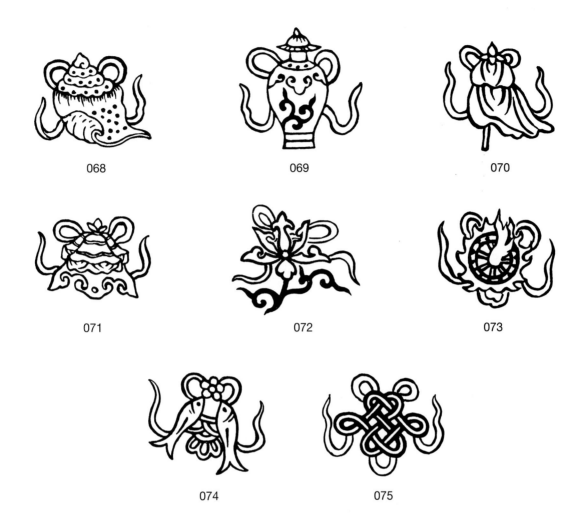

068 069 070

071 072 073

074 075

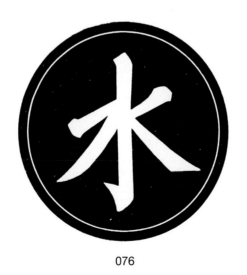

076

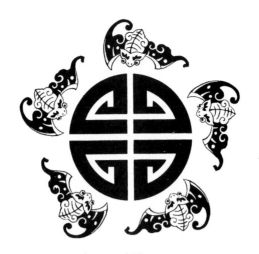

077

078

079

080

081

082

083

084

085

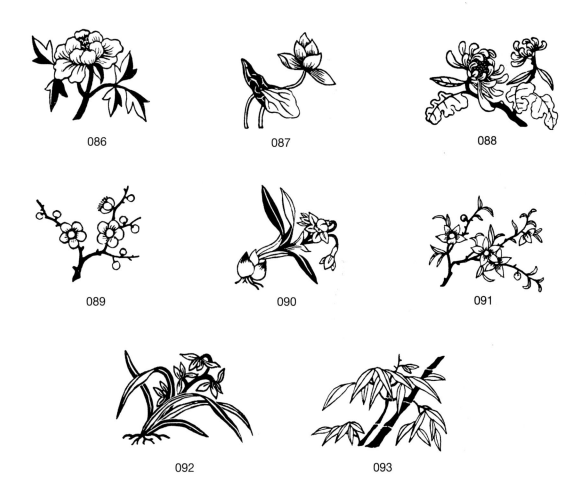

086

087

088

089

090

091

092

093

094

095

096

097

098

099

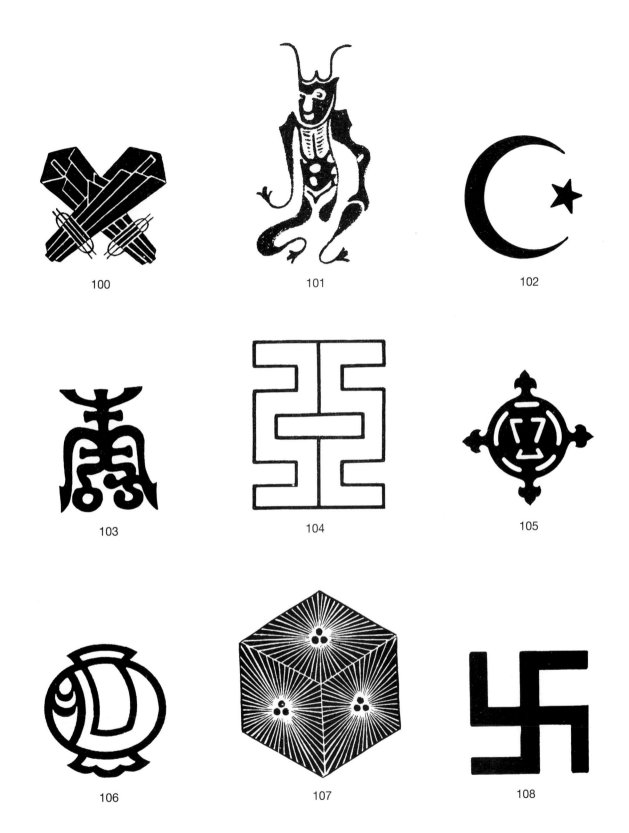

100

101

102

103

104

105

106

107

108

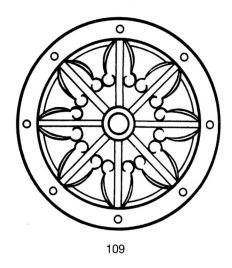

109

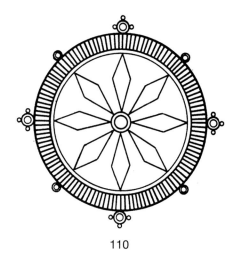

110

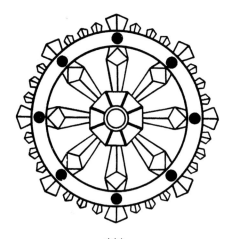

111

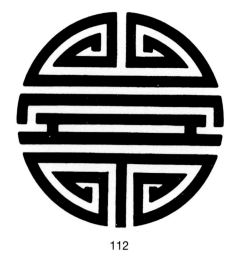

112

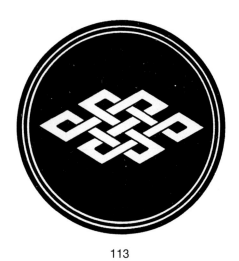

113

114

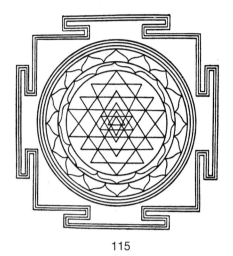

115

116

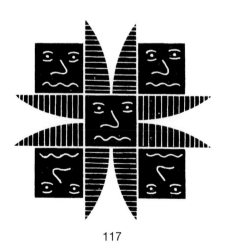

117

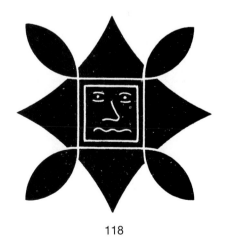

118

119

120

121

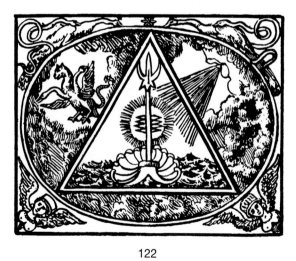

122

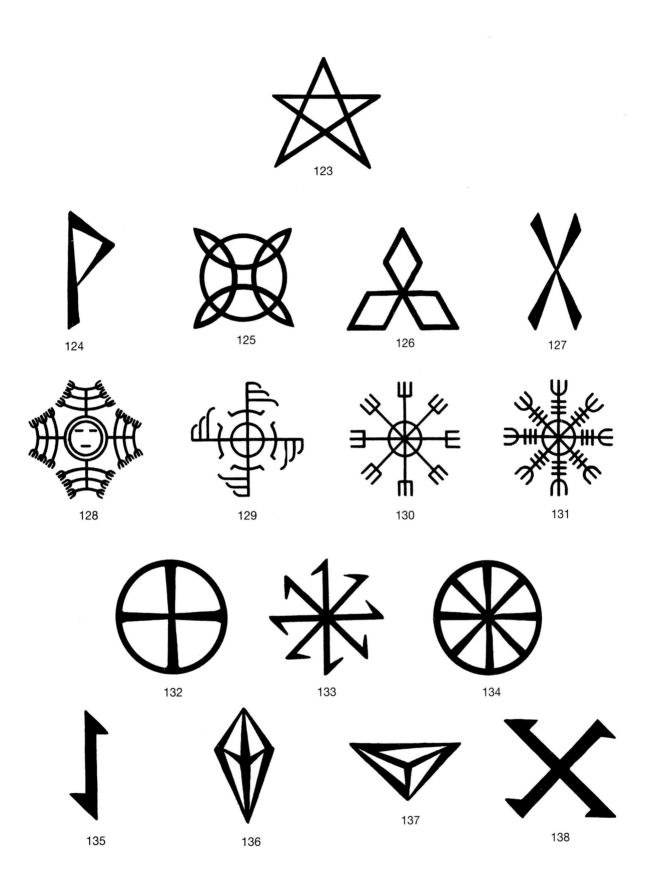

123

124 125 126 127

128 129 130 131

132 133 134

135 136 137 138

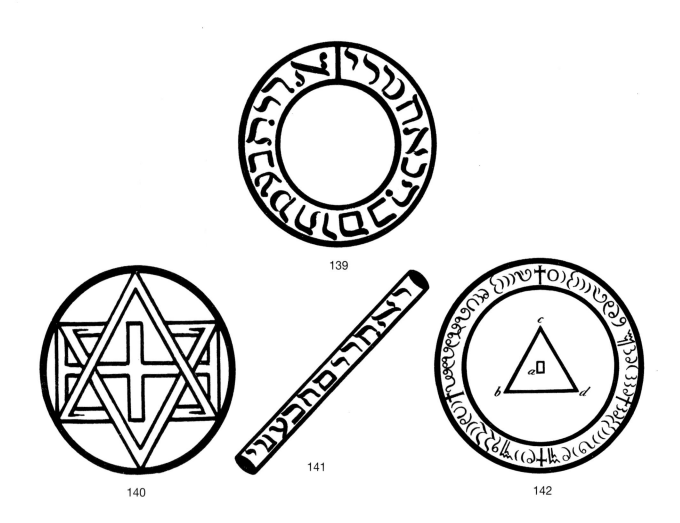

139

140

141

142

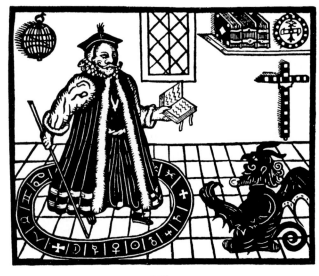

143

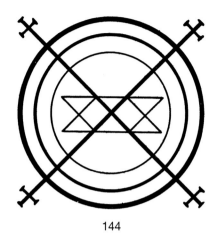

144

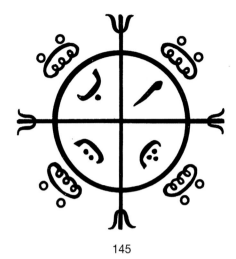

145

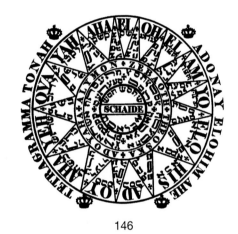

146

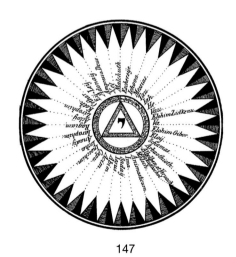

147

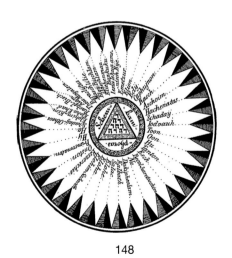

148

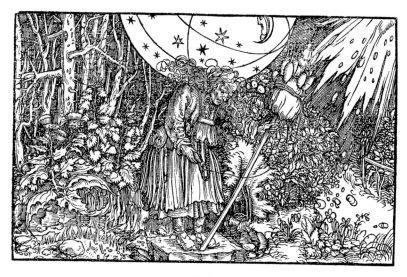

149

Michael.

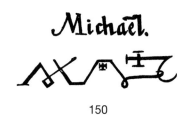

150

Gabriel.

151

Samael.

152

Raphaël.

153

Sachiel.

154

Anaël.

155

Caßiel.

156

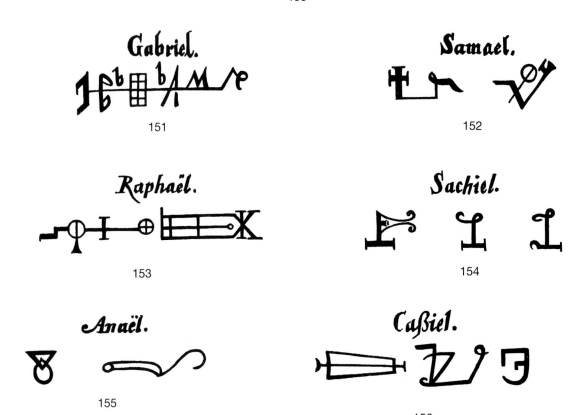

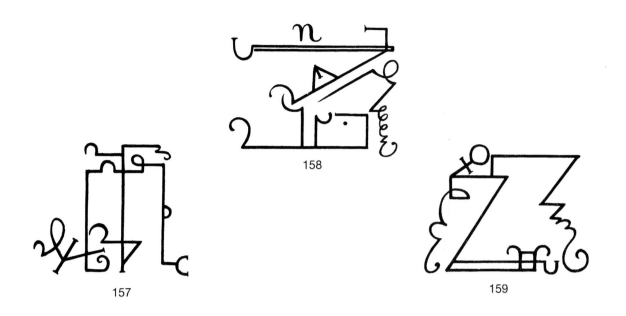

157

158

159

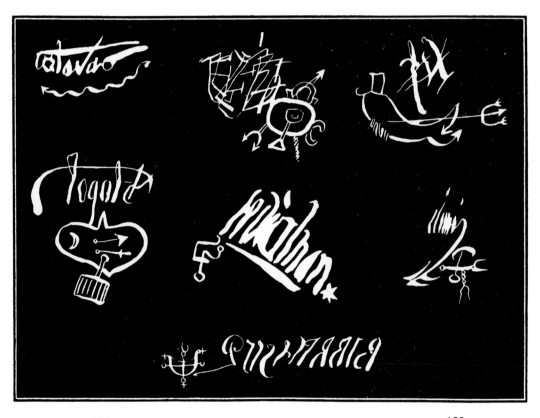

160　　　　　　　　　161　　　　　　　　　162

163　　　　　　　　　164　　　　　　　　　165

166

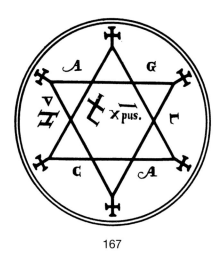

167

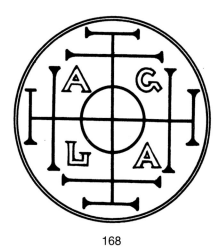

168

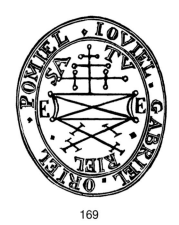

169

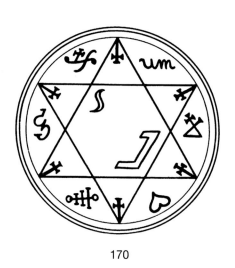

170

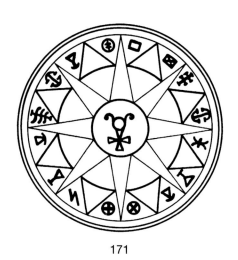

171